EARLY ITALIAN PAINTING

by Giovanni Previtali

McGRAW-HILL BOOK COMPANY

New York Toronto London

For a list of other titles in this series, see page 48

EARLY ITALIAN PAINTING

Anyone who has ever visited Italy knows that even today it is difficult to find two cities more different in taste, customs, spirit, and general appearance than Bologna and Florence, even though geographically they are so near each other. This was also true, as we shall see, in the fourteenth century in the field of art.

A look at a map shows that the Italian peninsula is sharply divided into two areas—northern and central-southern—by a range of mountains, the Apennines, which although not too high were sufficient to have once constituted a serious obstacle to exchange between the two areas. Thus, the relatively few kilometers that separate Bologna and Florence were, in the Middle Ages, kilometers of hard mountain road that required several days' journey to cover. Much easier, even at that time, were contacts between Florence and the other cities of Tuscany (Siena, Pisa, etc.) and nearby Umbria (Orvieto, Perugia, Assisi), on the one hand, and between Bologna and the other cities of the Po Valley (Modena, Parma, Milano, Padua, Venice) on the other. This accounts in part for the different cultural history of the two regions during the Middle Ages. The Po Valley in the north participated, in general, in the development of the art of central and western Europe (i.e. Germany and

France), and enjoyed an artistic production that can stand comparison with the great Romanesque and Gothic sculpture and architecture of the rest of Europe. Central and southern Italy, however, only felt partial and sporadic influences of the great artistic developments that gave birth to modern western art and remained bound, for the most part, to the eastern and Byzantine tradition, albeit in a distant provincial manner. The distinction between the two chief cultural regions of Italy is also marked quite clearly in linguistic differences. In the north, even today, people speak dialects of the Franco-Provençal group, and only in central Italy are typically Italian dialects spoken. Among these latter is Tuscan, which in the fourteenth century provided the basis for modern Italian.

A similar phenomenon, but one of more far-reaching effect, was experienced in that period in the figurative arts. This artistic effect was more widespread mainly because Italy has always

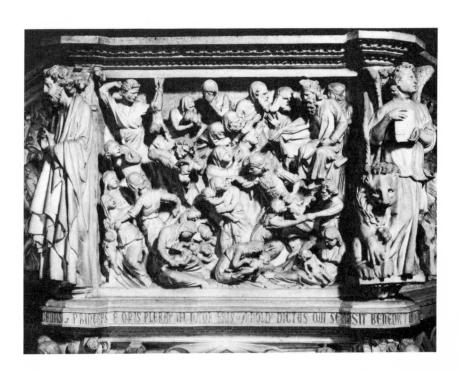

Figure 1. Giovanni Pisano: Massacre of the Innocents. Detail from the Pistoia Pulpit

produced more great painters, sculptors, and architects than great men of letters. The revolution in the written language affected a strictly limited group in comparison with the effect that the new vision of the world elaborated by Italian artists in those crucial years had on the whole area of western civilization of the period. Thus the period from 1250 to 1320 saw profound change in the situation of Italy and the beginning of a process of cultural unification with vast ramifications.

The Tuscan city of Florence, hitherto of secondary importance, became—thanks chiefly to commerce, banking, and its textile industry—a center of industrial, economic, and financial power of European significance. In the course of the fourteenth century, Florence's bankers, the Bardis and Peruzzis (the families who had their chapels decorated by Giotto), acquired an influence on the policies of various states as significant as that exercised in modern times by the Rothschilds and Rockefellers. The economic and political revolution that took place in Florence was part of the world-wide formation and rise to power of the *bourgeoisie*.

In the sphere of art the concomitant factors were the rise of a new class of patrons alongside the traditional ones (clergy and feudal aristocracy), a greater distribution of wealth, and an increase in commercial exchange with countries of higher culture (chiefly northern Italy and southern France). These facts created conditions that were particulary favorable to the development of a luxury industry such as the production of works of art. This situation also brought about a profound change in ways of thinking—of considering objects and the surrounding world—and made it possible for some artists of genius to effect an equally radical change in ways of representation, to develop a sense of the three dimensional and sculpturesque and a new feeling for dramatic naturalism.

Italian historical tradition, dating from the early fourteenth century, has indicated the outstanding figure in this develop-

ment—the Florentine artist Giotto di Bondone, who was the student of another Florentine, Cenni di Pepi, known as Cimabue. And we have no reason to deny such authoritative tradition when the simple comparison of the work of a teacher with that of a pupil can show us how well founded were the judgments of contemporaries (including the three patriarchs of Italian literature: Dante, Petrarch, and Boccaccio). If we compare a Madonna and Child by Cimabue or any other artist still bound to the Byzantine world, for example, the young Duccio, with one of the first works of Giotto (a work executed when the artist was still under thirty), the *Virgin and Child* of the small Florentine Church of San Giorgio alla Costa, it would seem at first sight that there is hardly any difference (*Slides 1, 2, 4*). The subject and iconography are the same traditional ones, but the manner of representing, the artistic idiom, is profoundly different. In the work of Giotto the shadows are far more pronounced (e.g., under the jaw) and, in consequence, the figures have far more relief. Compare, in particular, the two figures of the Christ Child. That by Cimabue is set parallel to the surface of the picture, almost flattened against the background. Giotto, with a few small but highly intelligent modifications (e.g., the turning of the left knee and the right hand, the vertical position of the roll in the left hand, the brief glimpses of the right foot and the thumb of the hand raised in benediction), has managed to have his figure take authoritative possession of the space. In short, he has given the figure a sculpturally plastic value.

But once he had taken this new turn, Giotto went even farther, as can be seen in his frescoes in the Church of San Francesco at Assisi (the center of Franciscan monasticism). Giotto was called to Assisi to narrate pictorially the life of a "modern" saint (St. Francis had been dead barely seventy years), and Giotto was the first to have the courage to face such a task in terms of contemporary history. That is to say, Giotto depicted St. Francis and his companions not according to an abstract and

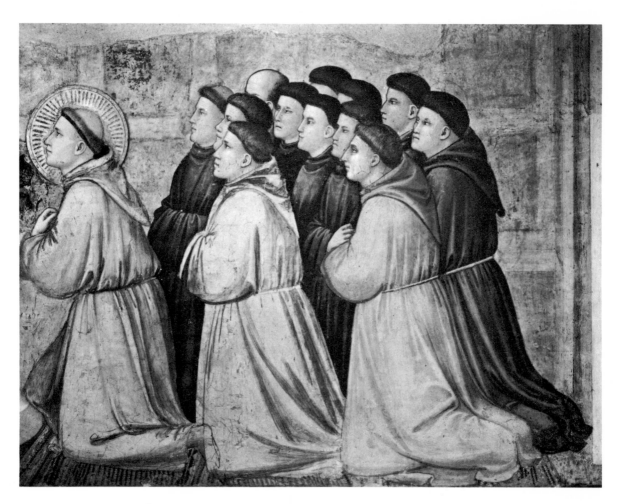

Figure 2. Giotto:
St. Francis Presents the Rule
of His Order to Honorius III
(detail).
S. Croce, Bardi Chapel,
Florence

7

Figure 4. Andrea Pisano:
The Art of Painting.
The Campanile, Florence

to revitalize painting so that it should be "seen," as the theater, and almost be "felt," as sculpture, must have had the overwhelming effect of an almost perfect illusionism. Thus, for his time, Giotto appeared to be one of those "who drew every figure and act from nature" (G. Villani), so that "many times in the things he did one finds that the visual sense of men was mistaken, believing to be real that which was only painted" (Boccaccio). And even Giotto's grandson Stefano could be called "the monkey [mimic] of nature" (Villani) and one of his figures could seem "to stand out from the wall" (Ghiberti).

The new vision of the world offered by Giotto in his paintings generally left the artists of the older generation indifferent. (But even among them, the more intelligent did not disdain to imitate their younger colleague.) But Giotto's vision was universally admired and assimilated by the painters of the younger generation. And not only because many of them were directly employed by the master in the workshop which he organized with a modern sense of industry, but rather because the new style was in complete harmony with the universally felt need to secularize and make more middle-class the modes of artistic representation. Although this corresponded to the change in mentality effected by the changed conditions of life, it should not, however, lead one to think that Giotto's task was necessarily an easy one.

We have mentioned that artists of Giotto's generation and the older artists were perplexed in the face of his radical break with the Byzantine traditions of art, which, because they went back so far in time (back to the Roman Empire!), were still supported by their venerable authority. Even the youngest artists hesitated to keep pace with the master's giant steps, and their "modernizations" remained years, if not decades, behind the rapid mental development of Giotto. The various groups of artists of the first half of the fourteenth century who are generally called "archaizing" are, for the most part, merely "conservative." This does not mean, though, that, considered in their

own terms, they do not often have great expressive capacity. Such is the case of the painting schools of Rimini and Umbria and even certain painters right in Florence (Pacino di Buonaguida, Jacopo del Casentino), who preferred to stop at the level of the anti-Byzantine plasticism achieved by Giotto at the age of thirty. Although these artists continued to work until the middle of the century, they either did not know or did not choose to follow Giotto in his evolutionary attempts to represent the visible world with even greater color and naturalism.

A similar attitude, albeit with a more courtly tone, of intelligent archaism and nostalgic fidelity to the world of the Eastern Roman (or Byzantine) Empire, marks the work of Duccio di Buoninsegna, an artist who is universally considered the founder of Sienese painting. This neighboring school was long considered the only rival of the Florentine school, although actually Siena owed much to Florence. If, instead of considering a youthful work of Duccio (*Slide 2*), we look at a work of Duccio's matur-

Figure 5.
Pacino di Buonaguida:
Polyptych.
Accademia, Florence

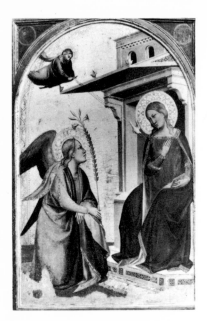

Figure 6. Taddeo Gaddi:
The Annunciation.
Bardini Museum, Fiesole

ity (*Slide 3*), we will see at once that certain fundamental elements of representation—the depth of space, the softness of flesh, the vivacity of narration—are clearly in the modern idiom. Nevertheless, the total effect is still that of solemn and ordered equilibrium and classic impressiveness, just as in the works that even then were considered "ancient." The comparable attitude in politics would be that of an intelligent conservative who recognized the necessities of the times but who still had so very much nostalgia for the good old days. And, in fact, it seems that in the political sphere Siena was a city in which aristocratic and conservative tendencies were far stronger than in Florence.

But to get back to Giotto; he must be our constant reference point because he was, throughout his long life, the most conscientiously innovative artist. After his work in Assisi, Giotto was called to work in Padua, a city of northern Italy, and thus, as far as painting was concerned, the barrier of the Appenines was broken once and for all . He went to Padua to decorate the chapel that a rich banker, Enrico Scrovegni, was having built in expiation of the sins of usury committed by his father. (The very sins which permitted the son to commission the chapel and its frescoes and to continue his father's business! Rarely has the conflict, and compromise, between traditional morality and a more modern mentality been so clearly exemplified.)

The subjects represented by Giotto on the chapel walls were taken from the Old and New Testaments. But the artist had so decisively made his break with the past that the traditional subject, instead of impeding him, spurred him on to even more daring innovations—even in iconography but most of all in style. The break with the style of Assisi was, in fact, so great that some critics have even attempted to deny Giotto's authorship of any work before the Scrovegni Chapel. But if the frescoes in Padua were the first works of Giotto, then his appearance in the world of art would only seem more inexplicable and miraculous.

To illustrate the frescoes of the Scrovegni Chapel, I have selected *Christ Appears to Mary Magdalen* (*Slide 6*), to show how much farther in style we have come from those at Assisi. But one can still easily follow Giotto's development step by step.

In this painting we see that the artist—who by now had altogether abandoned conventional Byzantine procedures—continued to labor over those problems of narrative clarity and convincing spatial representation that had been his chief concern at Assisi. But he also went beyond that severe plasticity of Assisi and faced an altogether new problem, that of color. This was the path he followed in his later evolution of style as was also the case with the followers of his later years, among whom

Figure 7. Maso di Banco: Miracles of St. Sylvester. S. Croce, Florence

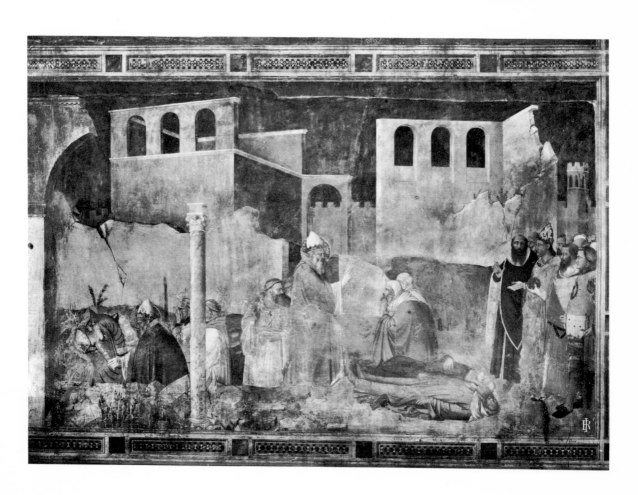

were some of the greatest Italian artists of the fourteenth century; Taddeo Gaddi, Maso di Banco, and the already mentioned Stefano, son of one of Giotto's daughters.

In the work of all these artists the attention to Gothic elegances and narrative vivacity gives way to a well-balanced and rhythmic narration and to deep, full, and majestic compositions. In particular, in Maso di Banco there is an attempt to harmonize spatial depth with the greatest and most controlled extension of color surfaces. This is a singular anticipation of the problems faced in the fifteenth century, in terms of the study of scientific perspective (especially aerial), by Piero della Francesca. This too is a classic, balanced, and in a certain sense aristocratic art, but how much freer and alive than Byzantine art! We have said that the students of Giotto kept out of Florence that calligraphic taste of Gothic expression which came from the north and which Giotto himself had encountered in Assisi. Naturally, this assertion is only true in part since, for example, there was a painter in Florence (who worked in Santa Croce, alongside Giotto), that mysterious and great master, generally called "The Master of the Fogg Pietà" (the "Maestro di Figline" for Italians), who united a power that can only be considered Giottesque, a nervous sense of outline, and a straining of forms that insistently call to mind certain expressions of northern European Gothic. Was the "Master of the Fogg Pietà" a foreigner in Florence, if only in the sense that he was a native of northern Italy?

But the real citadel of the Gothic in central Italy was Siena, where Simone Martini followed in a certain sense the path marked out by Duccio. Simone, however wanted to suggest an atmosphere of exotic courtliness, and of secular luxury, so he accentuated the linear elegances of French Gothic at the expense of Byzantine effects. This, too, is a sign that Giotto had seen clearly, that the times had been irrevocably changed, and that all of Italian culture was looking westward, attempting to assimilate what was most vital in that artistic tradition. Thus one

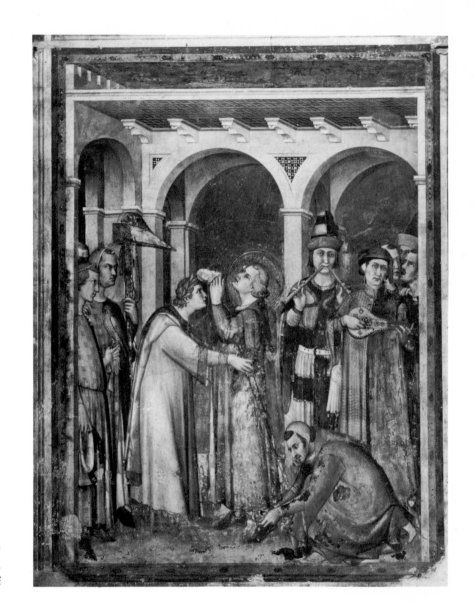

Figure 8. Simone Martini:
St. Martin Ordained a Knight.
S. Francesco, Assisi

15

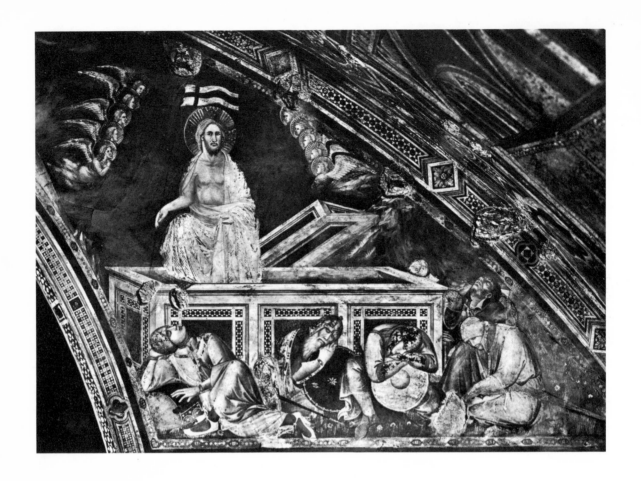

Figure 9.
Pietro Lorenzetti:
The Resurrection.
S. Francesco, Assisi

can say even in the case of Simone Martini—a great and consequently modern artist—that if the effects he attempted and achieved were certainly not the same as those of his Florentine contemporaries, nevertheless the language had the same grammar, the same syntax, the same unmistakable sound. His *Guidoriccio da Fogliano* would seem to be a heraldic image, but the landscape in which the figure rides is one that is aware of all the spatial discoveries made by Giotto; the profile of the rider is that of a real man—of a *condottiero* who had really existed (like Giotto's friars)—and not that of a formal prince-type. Although Simone Martini spoke Giotto's language, he said some strikingly original things: the landscape has a soft and continuous modula-

16

tion that had never been seen in the illusionary stage-like shadow boxes of the followers of Giotto; and physiognomic details are observed with a microscopic acuity. These are subtleties that anticipate developments that were to have great weight in the whole history of western painting (*Slide* 9).

Even more concerned than Giotto and his young followers with problems of space, and color in space, were the brothers Pietro and Ambrogio Lorenzetti. They too had worked in the churches of Florence, and Ambrogio was even enrolled, in 1327, in the guild of Florentine painters. After the first phase of development (still a part of thirteenth-century thinking), the art of Giotto and his Florentine followers soon took a position that was not so much in opposition to Byzantine art as much as it was in disagreement with certain formal and decorative extensions of French Gothic style. For the rational and logical thinking of Giotto's world, the calligraphic elegancies and linear mannerisms of Gothic style represented a far more insidious challenge than the worn-out Byzantine traditions from which they no longer had anything to fear. It was this mannered style that was best adapted to express the irrational unrest and passionate feelings generated by the tumultuous life of the period which—though controlled and dominated in Florence by the lucid minds of Giotto and Maso di Banco—appeared to some extent almost everywhere else. It was, as we shall see, an original development of Gothic expressionism that permitted Bolognese painters to express a whole world of erupting passions that were unknown to the measured balance of Florence and Giotto.

The Sienese masters, substantially dependent on those of Florence, continued to vacillate between the two cultural poles. Original combinations of Gothic linearism and Giottesque space can be observed not only in comparing the whole *oeuvre* of one master with another, but also in passing from one work to another by the same artist, and this is the case with Ambrogio Lorenzetti.

The Gothic pole, in its most aristocratic sense, is coherently represented by the work of Simone Martini. But this great artist did not have the following in Italy (for the reasons of *force majeure* to be discussed later) that could have been expected. (The sole exception is the mysterious figure of Barna da Siena.) In fact, the most modern possibilities of Simone's art were developed elsewhere.

About 1340, in fact, Simone Martini and his brother Donato, also a painter, moved to Avignon in Provence. Avignon had become the seat of the exiled popes and thereby acquired European eminence. In that rich and refined environment, the art of Simone found its warmest reception. For his art, so profoundly influenced by French Gothic, it was something like a return home. But in its move to Avignon the papal court had been profoundly changed. It had been transformed from the center for the preservation of medieval traditions into a meeting-ground for all currents of culture. And, as far as financial and bureaucratic organization were concerned, it was up-to-date with the most modern forms of capitalism. That meant that a painter with an open mind could find not only an incentive to effects of iconic solemnity but a stimulus to effects of profane luxury and display (always congenial to Simone's art) as well as to effects of narrative vivacity and realistic detail. This last aspect which already appeared in Simone's last works (he died in Avignon in 1344), had its greatest and most unexpected developments in Avignon in the work of another Italian genius, Matteo Giovannetti. This painter came from Viterbo in central Italy, and was the principal painter in Avignon from 1336 to 1367, when he followed the papal court in its first, provisional, return to Rome.

In the frescoes of the papal palace in Avignon, Matteo Giovannetti began with the "sublime" tone and fluid and continuous rhythm of Simone. But Matteo soon dropped this with a brusqueness that was impressive and turned to a concern for realistic detail, portraiture, vivid gesture, and the play of per-

spective. He covered the walls of the papal palace with prophets straight out of the ghetto and warriors who looked more like policemen than paladins. But the court had demands of its own, so Matteo heightened the golds and the ultramarines, the precious fabrics, the panels with passages from Holy Scripture rendered in elegant characters. And in his later development, Matteo Giovannetti tried, in fact, to reconcile his own realism with the abstract calligraphic qualities of northern Gothic. He

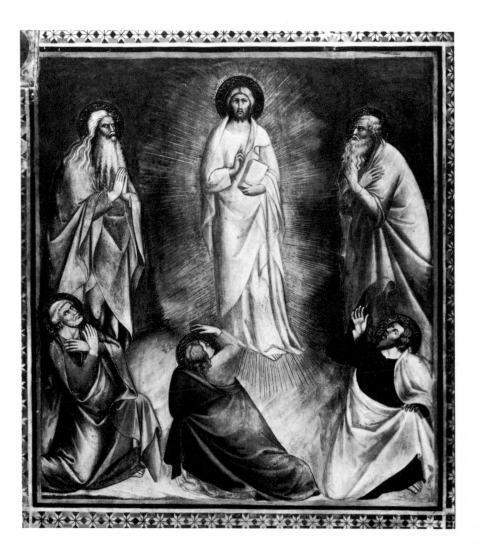

Figure 10. Barna da Siena:
The Transfiguration.
Collegiate Church,
San Gimignano

19

gave movement and relief to his "real" fabrics by arranging them in unlikely drapings, and he attempted natural color harmonies, but of the most refined and rarest kind (thus the harmony of rose and green). The result was, already in the middle of the century, the so-called "International Gothic style."

This Avignon aspect of the style begun by Simone Martini had echoes of some importance even in Italy. The most significant case in point is that of the 1345 polyptych of the Pisan painter Francesco Traini. In this polyptych he narrated with unequaled vivacity scenes and miracles from the life of St. Dominic. The style of this work has no convincing parallels in Italy, and one is tempted to think that this Pisan artist had somehow come into contact with the early work in Avignon of Matteo Giovannetti. (Either Traini had gone to Avignon at some point or he had seen some painting by Matteo.)

The painter in the city of Siena who suffered most from the attrition and insoluble contrast between the two leading cultures of Europe was the most intellectually complex, the most disturbed, the most "experimental" artist in that city—Ambrogio Lorenzetti. A kind of fourteenth-century Picasso with sudden spurts of genius, he was probably the greatest, certainly the most unprejudiced and unconventional of the great Sienese masters. At San Michele di Badia, Rofeno, he created a work that stands comparison with the most famous Italian Gothic painting: Simone Martini's lyrical calligraphic masterpiece the *Annunciation*. But Ambrogio was equally capable, in the "cinerama" effect he achieved in the frescoes of Siena's Palazzo Pubblico, of teaching something to even the most zealous adherents of Giottesque space. Ambrogio's concern with spatial depth is so evident in his paintings that, on the basis of certain tile floors depicted with foreshortening, some scholars have considered Ambrogio a precursor of Renaissance perspective. Possibly this point has been exaggerated and, if concern with space in Ambrogio's paintings is so striking (almost obsessive), this is simply because the total

Figure 11. Bernardo Daddi: Incidents from the Life of St. Stephen. S. Croce, Florence

balance of a composition was (with rare exceptions) for Ambrogio a problem he had to face and which was always unresolved. Ambrogio was an empiricist with intellectual ambitions. He loved complicated allegories but he achieved his best results working from intuition and inclination. All his life he sought an equilibrium and he never found it. In this sense he was singularly modern.

That classic solemnity which Ambrogio sought all his life (from the youthful *Madonna* at Vico l'Abate to the late *Maestà* at Massa Marittima) was in the very blood of his brother Pietro, as if it were a gift of nature. It is there in the polyptych that

Pietro painted in 1320 for the Pieve in Arezzo. Simple and monumental, that work has the same sense of quiet ease that characterizes the Florentine work of Maso di Banco. In Pietro's polyptych we see that the nervousness of the Gothic line alters somewhat the outlines of the figures. It makes draperies vibrate lightly, it gives a sinuous flow to hair and a particularly angular quality to the fingers, but it never threatens (as in the work of Ambrogio) to upset the towering solidity of the figures. In Siena, Pietro Lorenzetti was certainly the most qualified representative of the Florentinophile view. His scenes from the life of the Blessed Humilitas are in the Uffizi Gallery in Florence and a visitor who knew nothing about them would consider that they were perfectly at home in the company of other Florentine works. He might judge that they were painted by a Florentine of the generation of approximately 1330 who had a particular talent for narrative.

But the exceptionally favorable economic conditions that, throughout the first half of the fourteenth century, had fostered such a rich flowering of the arts (and here we have only considered the greatest masters, though many of the so-called "minor" masters were also artists of great skill) began to decline, and the outbreak of a terrible epidemic of bubonic plague in the summer of 1348—the sadly famous "Black Death"—took a dreadful toll of the two Tuscan cities Florence and Siena. The population of Florence was reduced from 90,000 to 45,000; the population of Siena declined from 42,000 to 13,000. Such a catastrophe could not but have the most disastrous results for the figurative arts as well. Some of the greatest masters (Ambrogio Lorenzetti, Pietro Lorenzetti, Bernardo Daddi) and many of the minor masters fell victim to the plague. Many of those who survived fled. The Golden Age of Florentine and Sienese painting had come to an end.

Figure 12.
The Master of Chiaravalle:
The Assumption Virgin (detail).
Camposanto, Pisa.
(This painting was destroyed
in World War II.)

Figure 13.
Giusto de' Menabuoi (?):
Madonna Enthroned
with Saints (1349).
Abbey, Viboldone

Among the many painters who abandoned Florence because of the plague was certainly a group of followers of the last style of Giotto, Stefano, and Maso di Banco. Distinctly in the style of Florence and Maso are, in fact, the paintings with which, toward the middle of the fourteenth century, the northern abbeys of Chiaravalle and Viboldone (1349 and after), near Milan in Lombardy, were decorated.

The Lombard patrons were in a certain sense predisposed to welcome the latest developments of the school of Giotto. For, according to a reputable contemporary source, Giotto had worked for the Duke of Milan in 1336 (one year before the artist's death) and he certainly left examples (now lost) of his late style, which was soft, fused, and warmly colored.

The outstanding figures of this later development, certainly Tuscans, were the anonymous artists who worked in the abbey of Chiaravalle, near Milan, and the author of the *Madonna Enthroned with Saints* in the Church of Viboldone. (Until World

War II there was an *Assumption Virgin* in the Camposanto of Pisa by an artist who worked at Chiaravalle.) The authorship of the *Madonna* in the Church of Viboldone has sometimes been attributed to the Florentine Giusto de' Menabuoi, who worked extensively in northern Italy, in Milan and more importantly in Padua, where he painted a famous fresco cycle in the Baptistery (ca. 1376-78).

What distinguishes these masters, and Lombard painting generally, from the Florentines and Sienese of the preceding

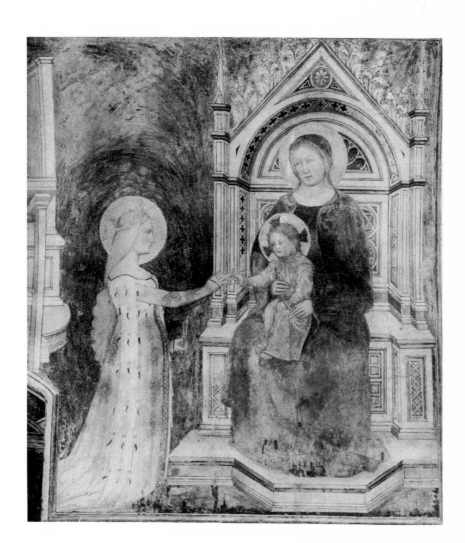

Figure 14.
The Master of Mocchirolo:
The Mystic Marriage
of St. Catherine. Brera, Milan

25

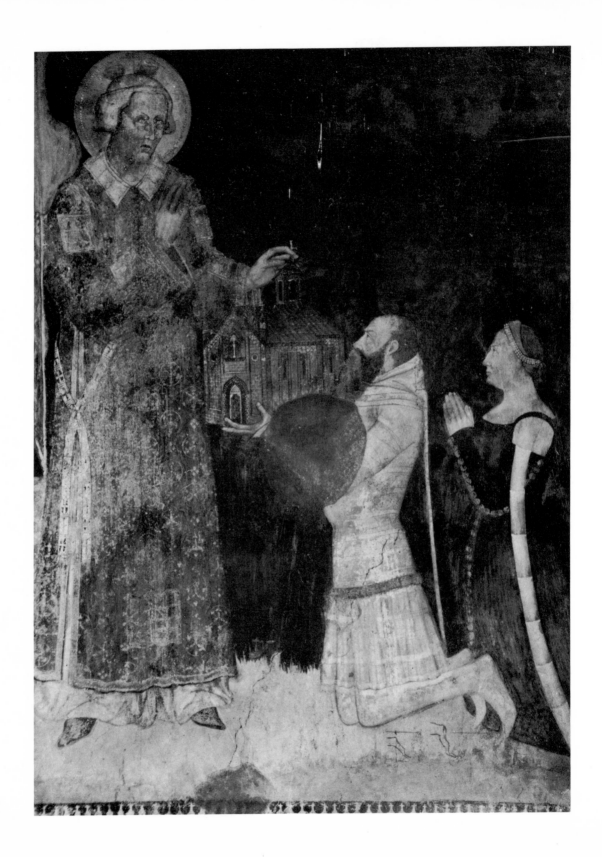

generation is chiefly a greater attention to naturalistic detail, a more iridescent color sense that is warm and deep, a nuanced sense of *chiaroscuro,* along with a new solemnity of presentation, no longer sacred but markedly secular. This last feature may reflect the Ghibelline and aristocratic culture of the northern courts, which was quite different from that of the central Italian communes.

The two most famous cycles of the new painting that developed in the second half of the fourteenth century in Lombardy are the one from Mocchirolo (ca. 1368; now in the Pinacoteca di Brera, Milan) and the one in the Oratory of Santo Stefano, in Lentate (ca. 1370). Both cycles, albeit by different artists, were commissioned by the same family, the Porros, who were closely bound to the lord of Milan, Galeazzo Visconti.

For the brilliant author of the paintings in the presbytery of the Oratory in Lentate, even the sacred drama of the Crucifixion becomes an excuse for the easy and solemn presentation of knights in armor whose strongly characterized faces and shiningly sweaty skin were easily recognized by contemporaries as the most realistic depiction of the men-at-arms of the Duke of Milan. And people could readily distinguish one by one the members of the Porro family, who are depicted elegantly dressed and in strict hierarchical order (first the father, then the mother, then the sons, and finally the daughters) as they present to St. Stephen the model of the oratory. (The painter here has forsaken the tradition of depicting saints as larger than common mortals.)

The author of this work is anonymous, and we cannot know if he was a Lombard by birth, although he certainly was in spirit. But certainly a Lombard by birth was the greatest Italian painter of the second half the fourteenth century, Giovanni da Milano. By a strange quirk of fate—but one that demonstrates that the cultural unification of Italy was well under way—one must cross the Apennines and enter northern Italy to study the

Figure 15.
The Master of Lentate:
The Porro Family
before St. Stephen (detail).
S. Stefano, Lentate

27

work of the Florentine Giusto de' Menabuoi, and follow the opposite road to admire the masterpieces of Giovanni da Milano. It was in Florence, in fact, in the years around 1365, that Giovanni began the fresco decoration of the Rinuccini Chapel in the sacristy of Santa Croce (the same church where Giotto, the "Master of the Fogg Pietà," Maso di Banco, Taddeo Gaddi, and Bernardo Daddi had worked). This work, finished by a modest Florentine follower of Giovanni, includes frescoes which are absolutely the most important ones painted in Florence after the middle of the century, both for pictorial qualities and originality of invention. And sixty years were to pass before anything comparable was to be done—the decoration of the Brancacci Chapel in the Church of the Carmine by Masolino and Masaccio.

The slow and soft modes of intense and continuous shaded color of Giovanni's frescoes, and the sureness and solemnity of the space and composition, reveal influences from the school of Maso. But the keen naturalism of the rendering of the material qualities of objects (the consistency of fabric, the luster of skins, the silkiness of hair, and the sparkling white of the cornea of the eye) already suggest that microscopic world of the Limbourg brothers and of the Van Eycks. And it is in this that one sees a non-Florentine element in Giovanni's cultural formation.

This is the ideal moment to turn back in time, for a moment, to look at the most bizarre and original Italian school of painting of the fourteenth century—the Bolognese school. We have held off considering this school till now just because of its relative isolation and rhetorical opposition to the Florentine ideals that had been so well received elsewhere. Although the main line of development of fourteenth-century Italian painting was undoubtedly that established by Giotto—with its rational and coherent representation of the world—it is nevertheless true that, strangely enough, the successive phase of evolution in Italian and European painting, the one known as "International

Gothic," seems in large part to contradict many Florentine values and to offer alternatives.

In the period from 1380 to 1410, compositions, instead of being broad and rhythmic with solemn figures, became dense and rich with minute episodes. Instead of falling solemnly in simple masses, the draperies were agitated in the most incredible and abstract arrangements. Several successive phases of a single narrative are set in the same scene, not in a single and rationally controlled space but in an unreal space that goes off into infinity. This would seem to represent the absolute victory of Gothic calligraphy over the neo-Romanesque art of Giotto and, above all, of Lombardy. This would never have been possible had the most vivaciously expressive Gothic tradition not been kept alive by some artists of genius. We have already noted a certain Gothic strain in some Sienese painting, particularly in Avignon, but it was chiefly in northern Italy, where a similar attitude could sink even deeper roots in local traditions, that an entire school of painting, that of Bologna, could oppose painting in the Florentine manner with a different concept. This concept was all narrative vivacity—with its sudden starts and expressive distortions of artistic grammar—and it constituted one of the most important components for the late explosion of International Gothic style. But the influence of Bologna was assimilated, as far as it was possible, in the composition of epidermal truths and representational solemnity of Giovanni da Milano.

The acknowledged founder of the Bolognese school of painting was, between 1330 and 1350, Vitale degli Equi, known as Vitale da Bologna. The rediscovery of his vivid art is a recent development. His art was long misunderstood by academic critics who attempted to judge it according to abstract criteria of "composition," "regularity," "coherence," and "logic," that is to say, the very qualities that the painter denied and opposed in every one of his works and with all his force. Modern art his-

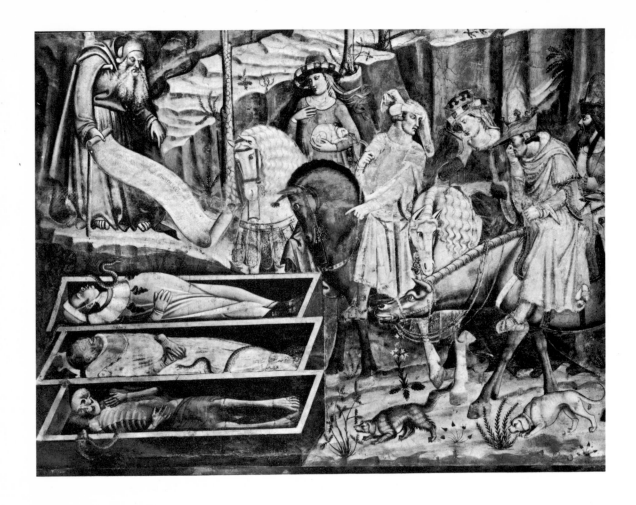

Figure 16. The Master of the Triumph of Death: Detail from The Triumph of Death. Camposanto, Pisa

tory—with its exhaustive study of contemporary painting and its searches even into the past for all sorts of expressionism and fauvism—was not impeded by such taboos and has loudly proclaimed Vitale da Bologna as one of the greatest painters of the fourteenth century and of all time. Vitale's style, based on an entirely popular taste for vivid narrative, has paradoxically seemed to be a problematical style for critics raised in an entirely different cultural tradition. His style is a delicate balance between the naturalistic experimentation of the "Lombard" type and Gothic unreality stemming from French influence. He rejected the measured ordering of masses of Giotto and his fol-

lowers, as well as the aristocratic cadences of the Sienese. Thus it is quite clear how, in the work of his latest followers, his art could be reduced to the level of a brutal popular expressionism.

But Vitale was not the only great artist of the Bolognese school. We must, at least briefly, mention the anonymous miniaturist who is called by a name that is at once a critical definition—"L'Illustratore" (the Illustrator). This artist, who illustrated both religious and legal texts (Bologna was the seat of a famous university), was able to take full advantage of his new freedom from all religious and iconographic conventions and left us a free and imaginative chronicle of the life of his times, even if in its most offhand aspects, they are comic or crude.

Between 1350 and 1380 the specifically Bolognese tradition of painting was kept alive and at its highest level of expression by the third great master of the school, Jacopino di Francesco de' Bavosi. This master, who had been formed after examples of the school of Rimini, led the local school, which seemed about to accept Florentine influence, back to the expressionistic tradition of Vitale. But Jacopino accentuated even more the latter's characteristics of violence and popular brutality. The force of the sentiments expressed did not, however, in any way, detract from the refinement of his pictorial execution. On the contrary, he achieved such a surprising combination that he may even be the most strongly original and most astonishingly modern of the painters of his time, notwithstanding the fact that his very originality may have prevented him from having an immediate following.

Turning back mentally a few decades, to about the middle of the century or slightly later, we find certain artistic intentions and actual results prefiguring International Gothic and combining achievements of Vitale da Bologna with those of the Avignon style of Simone Martini in one of the most famous frescoes of the fourteenth century, the *Triumph of Death* in the Camposanto of Pisa. Some critics attribute this work to the Pisan artist Fran-

cesco Traini (who had been in Avignon), while others insist that it is certainly the creation of a Bolognese artist. The work boasts realistic elements (the group of beggars who invoke Death), elements of narrative vivacity (the three horsemen who come on the open coffins), and an "impressionistic" freedom of execution (particularly in the preparatory drawing, or *sinopia,* that was revealed when the frescoes had to be removed from the wall after damage in World War II) that were absolutely unknown to the minor Tuscan artists of the second half of the century (the Orcagnas and their school). Furthermore, in this period there are several examples of the spreading influence of Bolognese painting—throughout the Po Valley and even in Tuscany (in Pistoia, Arezzo, and Florence). As far away as Venice, which long remained an artistic child of Constantinople (to which she was bound by her maritime activity), the leading painter of the second half of the century, Lorenzo Veneziano, managed to shake off the rigidity of Byzantine classicism thanks chiefly to the mediation of Bolognese work, and this had certain consequences as well for northern European painting (in Austria and Bohemia).

For about fifty years, from 1370 to 1420, these were the Gothic modes that, in a more strictly courtly manner and often fatuously decorative style, were to triumph in Lombardy and then in France, in Bohemia, and in Spain and Tuscany as well, and establish the common pictorial language of civilized Europe until the triumph of the Renaissance.

· 1 ·

CIMABUE
(ca. 1240–ca. 1302)
*Madonna
Enthroned with Angels*
Panel, 108½″ x 167″
Louvre, Paris

According to Vasari (*Lives*, 1550), this immense panel was painted for the Church of S. Francesco in Pisa, where it remained until Napoleon carried it off to Paris as war booty.

It is one of the very few works that can be attributed with certainty to Cenni di Pepi, known as Cimabue, the painter mentioned by Dante in the *Divine Comedy* and universally considered the patriarch and founder of that school of painting in Florence which was to produce, in succeeding centuries, Giotto and Masaccio, Botticelli and Michelangelo.

The Madonna is depicted "in majesty," that is to say, as a queen seated on a throne in the glory of heaven (symbolized by the gold background) and surrounded by six angels. The Christ Child is depicted at a fairly mature age, in the traditional pose of blessing with His right hand and holding the scroll of divine law in His left. In the frame are twenty-six round panels with half figures of apostles and saints.

The work may be considered as later than the frescoes that Cimabue painted in the Church of S. Francesco in Assisi (1277-80) and should probably be dated about the time of the Rucellai Madonna by Duccio di Buoninsegna (1285; *Slide 2*).

In this work Cimabue seems to be still strongly under the influence of Byzantine style and iconographic usages and not at all aware of the innovations of Giotto *(Slide 4)*.

The faces of the Madonna and the angels are painted after the same type and reveal the use of eastern styles of schematization in the handling of the circles under the eyes and the arch of eyebrows and of the nose. The angels, dressed in ancient manner, are arranged around the central figure in strict symmetry, and this is applied even to their gestures. There is no sense of spatial depth and body weight. The dense lines that mark the folds of the garments contribute to the annihilation of plastic form at the same time that they try to emphasize it. Together with the tenuous and subtly harmonized colors (orange, pale pink, blue-grey), they end by giving the picture the aspect of an incorporeal and fluttering apparition.

**DUCCIO
DI BUONINSEGNA**
(ca. 1255–ca. 1318)
*Madonna Enthroned with
Angels (The Rucellai Madonna)*
Panel, 114″ x 177″
Uffizi Gallery, Florence

In this panel the Madonna is depicted "in majesty" as in Cimabue's panel in the Louvre *(Slide 1)*. This panel was long considered the work of Cimabue. But although there is a similarity of representational conventions (derived from Byzantine art), some stylistic peculiarities distinguish this panel from the works of Cimabue and assure its attribution to the youthful period of the founder of the Sienese school of painting. Stylistic considerations allow us to identify the panel with the one that, according to a document, Duccio agreed to paint for the laudators of the Church of S. Maria Novella in 1285.

At this early date Duccio still had not assimilated those elements of the art of Giotto that were to be an essential part of his later art; nevertheless he already displays typical characteristics that were to become the common inheritance of the art of Siena. To the classical compositional principles (balance and symmetry) and the Byzantine manner of reading a picture, Duccio added a far subtler and more complex counterpoint in composition and an accentuation of elements rhythmically repeated like the chorus of a song. With regard to the first aspect, consider, for example, in the pair of angels kneeling below, the alternation of colors in the tunics and mantles (blue-mauve, mauve-blue) that binds them to the second angel on the left (blue mantle, mauve tunic), which is in turn related to his companion on the right by the color of the mantle (mauve). Such links are repeated throughout the picture.

As for the second aspect, note the importance of using the Gothic motif of outline as a determinant and expressive element. The outline functions as a musical-compositional ligature of the various elements of the painting, and everything is subordinated to this. Thus the angels are so markedly cut off as to make them appear laid out one over the other. In this way the reading of forms is continuous and not interrupted by one form intruding on another. The mantle of Mary is not, as in Cimabue, densely marked with folds imitating sculpture. Instead it is left almost as a single color area to give greater brightness to the figure. The form of the figure is completely determined by the flowing outline and by the sinuous and fluctuating line of the golden border.

DUCCIO
DI BUONINSEGNA
(ca. 1255–ca. 1318)
*The Visit of St. John
to the Virgin*
Panel (detail of the Maestà)
Museo dell'Opera del Duomo,
Siena

This monumental panel, with paintings on both sides, was executed for the high altar of the Cathedral of Siena (Madonna in majesty, angels and saints, Crucifixion, and numerous scenes from the life of Jesus and the life of Mary). The commission was given to Duccio by Jacomo Mariscotti, director of works for the Cathedral.

The detail reproduced here depicts a scene from an apochryphal legend, according to which Mary moved to Ephesus (Asia Minor; modern Turkey) after Christ's death. There an angel informed Her of Her imminent death. She wished to see the apostles for the last time, and they were miraculously brought together. Here Mary receives St. John. Outside the room ten apostles (the one to the extreme left in the background is St. John again) frame the meeting of St. Peter and St. Paul.

The observations made on slide 2 are for the most part applicable to this work as well. Notice, for example, with what skill the two groups are balanced. They are united by the light blue that predominates in the group of apostles in the foreground and that returns, on the right, in John's robe. Noteworthy too, is the assimilation of some stylistic novelties of the art of Giotto. Thus, in the room on the right, Duccio tries to render spatial depth by having the ceiling beams converge and by deforming the arches of the doors so that they appear to be seen at an angle. But the fundamental principles of Duccio's art remained distinctly original and were always based on the values of balance and rhythmic continuity of narration.

· 4 ·

GIOTTO DI BONDONE
(ca. 1266–1337)
*Virgin and Child
with Angels*
Panel, 35½″ x 71″
San Giorgio alla Costa,
Florence

This work is mentioned in old sources as a work of Giotto, and it can certainly be attributed to the period of his youth (1285-ca. 1295).

Originally the architecture of the throne, which one can barely see on the sides (at one point the panel was trimmed on the sides and at the bottom to be fitted in a baroque frame), must have been a very important element and must have contributed to the effect of spatial depth.

The iconography is not far from the traditional, and the Child is represented, as in many Byzantine panels, in the act of blessing with His right hand and holding the scroll of the law in His left hand. The Virgin stares straight ahead. But the manner of representation is completely new: the chiaroscuro (under the jaws of Mary and Christ, on the scroll of the law, and under Christ's right foot) gives the figures a strong sense of relief, as does the handling of the few folds of drapery, deeply hollowed out, as in sculpture, and skillfully arranged.

The hand of a painter who is consciously renovating traditional painting is apparent in a host of small details: the right hand of Christ in the gesture of benediction, with the thumb over the other fingers, and the last two fingers bent back; one foot seen from above and the other in profile; the left hand of the Virgin embracing the body of the Christ Child from behind, to emphasize the detachment from the background, etc.

· 5 ·

GIOTTO DI BONDONE
(ca. 1266–1337)
*The Death of the Knight
of Celano*
Fresco
San Francesco, Assisi

The subject of the fresco is an episode of the legend of St. Francis according to St. Bonaventure. Francis was invited to dinner by a noble knight of Celano. Foreseeing the knight's imminent death, Francis hears his confession and has him prepare his will. And as the knight sits down to dine he suddenly dies.

Giotto has depicted the culminating scene of the legend. The fresco belongs to a cycle that was executed, probably between 1295 and 1300, under the direction of Giotto but with the extensive collaboration of assistants. This is one of the scenes in which the hand of the master is most evident. But even here, while some parts are very strong and anticipate stylistic solutions applied in the Scrovegni Chapel *(Slide 6),* others, such as the group of heads that surround the woman with folded hands, are weak and must be considered the work of an assistant.

Nevertheless the characteristics of Giotto's mature art are clearly recognizable. The spatial area is clearly marked off; the viewer's eye is led along the chain of glances and gestures to concentrate on the dramatic apex of the composition, the woman holding the dead man. In certain details, such as the tablecloth and the placid face of St. Francis, there are subtler coloristic modulations that mark a development away from the sculptural effects of Giotto's youth and toward the richer and more highly colored style of Padua and later works.

· 6 ·

GIOTTO DI BONDONE
(ca. 1266–1337)
*Christ Appears to Mary
Magdalen (Noli me Tangere)*
Fresco, 71″ x 78¾″
Scrovegni Chapel, Padua

This fresco is part of the decoration of the Scrovegni Chapel in Padua and is dated around 1305-06, when Giotto was about forty. Thus this fresco is an authoritative example of the master's mature style. It represents the Risen Christ (on the banner is written *Victor mortis,* conqueror of death) appearing to Mary Magdalen. He tells her *Noli me tangere,* "do not touch me."

The work may be considered as entirely by the master's own hand and is one of the greatest masterpieces of Italian art. In comparison with the frescoes in Assisi, the solid structure of the figures is rendered with less severity and the rotation of planes is softened by the warm fused color. Above all, there is the subordination of the compositional elements to achieve an absolute narrative clarity. Notice how carefully selected are the poses of the soldiers to suggest deep sleep. Notice, too, how the gestures of the angels direct the attention to the dramatic apex of the scene, which is set on the right. Notice, finally, how effective is the Magdalen's gesture and the slow withdrawal of Christ. Observe also how a general compositional balance is achieved: one angel balances another; one soldier leans to the right, the other to the left. And the whole composition is supported by a single diagonal that runs from the upper left to the lower right.

· 7 ·

MASTER OF THE
FOGG PIETA

Lamentation over the Body
of Christ (Pietà)
Panel, 16⅞″ x 19¾″
Fogg Art Museum,
Harvard University, Meta and
Paul J. Sachs Collection

This panel has suffered some abrasions, which the modern restorer has filled in with broken-line coloring. The painting is famous for having given a name to one of the greatest and most mysterious Italian masters of the fourteenth century. (In Italy the conventional name applied to this painter is the "Master of Figline," for another famous painting by the same artist—a *Maestà* in Figline Valdarno, near Florence.)

Everything we can say about this artist is deduced exclusively from stylistic considerations. The carefully balanced composition and the massiveness of the figures suggest that the artist's milieu must have been that of Florence and Giotto. Nevertheless other features make it clear that this artist could not have been aware of the later developments of Giotto's art. For example, there is a marked simplicity in the alternation of the positions of the figures (e.g., Mary is depicted facing the viewer and is balanced by a figure with back to the viewer; St. John leaning away from the viewer is balanced by Mary Magdalen leaning forward and facing the viewer; Nicodemus frames the picture on the left, and St. Joseph balances him on the right). There is a comparable simplicity in the *variatio* of the color areas. One bit of evidence in favor of this hypothesis is the fact that there are works by this artist in Assisi as well as in Florence. We must still point out the most personal stylistic characteristic of this artist, that is to say, the vibrant and enclosing outline that delineates the forms (from the rounded heads of the women to the curls of St. John, to the nodulous legs of Christ), which is quite different from the Florentine manner of squaring figures, and the flowing outlines of Sienese painting. This fact has often led critics to believe that the painter was not Italian or at least from the north of Italy.

What is certain is that this outline, which is so "functional" and expressive, recalls elements of the "expressionistic baroque" of Carolingian miniatures, elements of the Master of Sant'Agata from Cremona, and certain thirteenth-century mosaics in the Baptistery in Florence. At the same time it surprisingly anticipates certain formal solutions achieved by the fifteenth-century Florentines (Baldovinetti, Pesellino, Filippo Lippi).

· 8 ·

MASO DI BANCO
(ca. 1300 ca. 1347)
St. Julian and St. Catherine
(detail of a polyptych)
Panel, approximately 33½″ x 33″
Santo Spirito, Florence

These two saints are part of a polyptych in the center of which is a Madonna and Child; the left wing depicts Mary Magdalen and St. Andrew. It is one of the works most certainly attributed to the Florentine painter Maso di Banco, perhaps the greatest follower of Giotto's last period. On the basis of style, this polyptych can be dated to the fourth decade of the fourteenth century.

Maso has taken from Giotto the aristocratic tone and the attention and concern with problems of color and space. With regard to the aristocratic tone, the choice of saints is significant—Julian the saintly knight and Catherine the holy princess—as is the *recherché* elegance of their apparel and the haloes with elaborate metallic decoration. The warm tone of St. Julian's cloak and the delicate white and gold of Catherine's gown suffice to indicate what a fine colorist was at work.

As for Maso's concern with space, note the carefully studied angles of the right hands of both saints and, even more striking, the graduation in space of the leaves of the palm branch, the symbol of martyrdom. This last invention is worthy of the finest perspective effects of the fifteenth century.

· 9 ·

SIMONE MARTINI
(ca. 1285–1334)
Guidoriccio da Fogliano
Fresco
Palazzo Pubblico, Siena

This fresco commemorates the victory of Guidoriccio Ricci dei Fogliani of Reggio Emilia, Capitain-General of the Sienese, over Castruccio Castracani, lord of Lucca and chief of the Ghibellines in Tuscany, from whom Guidoriccio captured the citadels of Montemassi and Sassoforte. The fresco bears the legend "ANNO DOMINI MCCCXXVIII" (1328), which is the date of the military victory and probably the year in which the fresco was painted.

Over the fortress in the center, where one can note a catapult, wave two banners: the black and white banner of Siena (the famous *baldanza*) and a banner with blue lozenges on a yellow ground with plant motifs. This banner must have been that of Guidoriccio since the same decorative motifs adorn the saddlecloth on the horse and the rider's apparel.

On the right is a bird's-eye view of the Sienese encampment with straw huts for the soldiers and elaborate pavilions for the officers. On the hill to the left is a fortified town.

Simone Martini achieved an effect of great poetic intensity by isolating the figure of the protagonist in the center of the fresco, and by setting him in the foreground gives him the greatest importance.

A sense of the horse's movement is suggested by the very form—long and narrow—of the painted surface, and the rhythmic gait is suggested by the lower edge of the saddle cloth, which waves and rustles. The landscape recalls the spatial effects of Giotto's followers, but Simone's handling is altogether different. The followers of Giotto achieved a tight sense of sureness. Here there is modulated ease.

38

· 10 ·

SIMONE MARTINI
(ca. 1285–1334)
Annunciation (detail)
Panel, 120″ x 104″
Uffizi Gallery, Florence

The slide reproduces only the central part of the painting. At the sides stand figures of Saints Ansano and Massima; above is the Holy Spirit in the form of a dove, surrounded by seraphim. Below, in the center, is a vase with lilies, the symbol of purity.

The present frame was probably added in the nineteenth century, but part of the original frame is included in it and bears an inscription: "Simone Martini and Lippo Memmi painted me in the year of our Lord 1333."

Lippo Memmi, the brother-in-law of Simone Martini, came from a family of artists, but his style was so influenced, after a certain period (ca. 1320), by that of Simone, that it is impossible to distinguish their work. Consequently critics agree in considering this painting as if it were by Simone alone.

Stylistically the most noteworthy feature is the use of outline in a dominant expressive function: consider the rippling cloak of the angel and the ribbons holding his hair and, even more, the carefully withdrawn attitude of the Virgin. Notice, too, the many details: the highly eclectic and bizarre form of the vase, the trim on the angel's garment and on Mary's cloak, the binding of the book, the radiant haloes, the Gothic letters running from the mouth of the angel to Mary's ear: AVE GRATIA PLENA DOMINUS TECUM. The composition is sustained by very simple and sweet harmonic cadences: the two hands of the angel and the two hands of the Virgin; the parallel curves of the bodies, etc.

· 11 ·

MATTEO GIOVANNETTI
(ca. 1300–ca. 1369)
Visitation
Fresco
Carthusian Church,
Villeneuve-lez-Avignon

This fresco depicts the meeting of Mary and Elizabeth as described in the Gospel according to St. Luke (I;39-43): "And Mary arose in those days, and went into the hill country with haste, into a city of Judah; And entered into the house of Zacharias, and saluted Elizabeth . . ."

The fresco is part of the decoration of the chapel that Pope Innocent VI had erected at the Monastery of Villeneuve, and is attributed to Matteo Giovannetti of Viterbo, who was then the chief painter of the papal court (which at that time was settled in Avignon).

The style of the fresco, in fact, is altogether Italian and marks a further development of the Gothic art of the Sienese painter Simone Martini who also had worked at Avignon in the last years of his life).

Elements derived from the art of Simone include the marked concern with portraiture and the use of certain facial types, for example, that of Mary with the fine arched eyebrows; the elegance of the extremely elongated figures; the refined range of color, which attempts delicate harmonies of soft tones and iridescences.

Matteo's architectural forms, although they are trimmer and more daring, also hark back to Giottesque examples. Notice the illusionistic effect he attempted by pictorially camouflaging the edge of a real window (on the left) to coincide with the corner pilaster of Elizabeth's house.

· 12 ·

FRANCESCO TRAINI

St. Dominic Rescues
the Shipwrecked
Panel, 17½″ x 19½″
National Museum, Pisa

This scene is part of a triptych the center of which depicts the standing figure of St. Dominic and the sides of which have eight scenes from the life of the saint (four to a side).

The slide shows the sixth scene, representing the episode of the English pilgrims on their way to the sanctuary of Santiago de Compostella. In order to avoid the city of Toulouse, the center of the Albigensian heresy, they attempt to cross the Garonne in a small boat, are shipwrecked and miraculously saved by St. Dominic.

Although only a few works are known, Francesco Traini, probably a Pisan by origin, is considered one of the major Italian painters of the fourteenth century because of his strong originality. He has quite rightly been assigned to that stylistic trend that developed from the courtly Gothic style of Simone Martini, a trend that developed new expressionistic and popularizing tones.

The first feature to be noticed is the extraordinary vivacity and realism. Thus, the saint, although distinguished by the halo, is really and physically present on the river bank, and the hirsute pilgrims embrace his legs and kiss his feet. That the possibility of vividly depicting an everyday scene particularly interested the painter is clear from the insertion of secondary episodes, which are among the most felicitous parts of the picture: the child on the right who peeks curiously from behind St. Dominic; the shipwrecked man brushing back his dripping hair; the two children on the left who are shouting and pointing to an old man, who strongly recalls the elongated and agitated figures of prophets that Matteo Giovannetti painted at Avignon.

· 13 ·

**AMBROGIO
LORENZETTI**

Saint Michael
(detail of a polyptych)
Panel
Diocesan Museum, Asciano

When this panel was discovered, it was part of a triptych with a Madonna and Child and Saints Benedict and Bartholomew Apostle (full size: 87½″ x 97½″); this triptych had been altered in the sixteenth century, so it is not certain that the panel of Saint Michael was originally part of it.

In the stylistic development of the Sienese Ambrogio Lorenzetti, this painting should be placed at the end of his Florentine period (ca. 1319-32) and before the frescoes of the Palazzo Pubblico (1338-40; *Slide 14*). It appears to have been done in a period in which, having returned to his native city, Ambrogio Lorenzetti seems almost to have forgotten the Florentine spatial experiments and to have rediscovered with enthusiasm the linear idiom of Simone Martini.

The whole figure of the warrior saint is, in fact, synthesized into a kind of immense "S"; the borders of his cloak are extremely serpentine, and the arabesques of the armor accentuate the sense of motion and continual vibration. Because of the greater taste for sinuous line and flowing forms, the dragon has seven serpent heads and a very long tail knotted several times on itself. The almost flying lightness of the Archangel is accentuated by the cloak, which like a parachute is full of air pockets.

40

AMBROGIO
LORENZETTI
(ca. 1290–ca. 1349)
Good and Bad Government
(detail)
Wall painting, approximately
196½″ x 136″
Palazzo Pubblico, Siena

On the wall on which the allegory of Good Government (ca. 550″ x 136″) is painted there appears the signature of the painter. The cycle of paintings was paid for, according to the documents, between 1338 and 1340.

In this painting Ambrogio takes advantage of everything he learned about spatial construction in Florence, from Giotto, Maso di Banco, and Taddeo Gaddi. This is evident, above all, in his solution to the difficult problem of depicting the walls and the gate of the city seen at an angle.

This should not, however, lead us to consider this representation as a "landscape" in the modern sense. Rather, it should be considered as a "map" of the Sienese state, all spread out before our eyes with the idea of didactically presenting the advantages of Good Government—in particular the advantage of Safety, whose allegorical personification (SECURITAS) is prominent. Safety is depicted in the upper left in the guise of a nude maiden with a hangman's fork and a placard with a hendecasyllabic verse. Along the border below is another warning legend. This does not keep us from admiring the extraordinary poetic effect that the artist achieved. It is clear that Ambrogio must have enjoyed himself in representing the outlines of various types of trees, the different kinds of residences, and the different occupations of men: peasants carrying their wares to be sold in the city, hunting with the crossbow, and in the fields.

PIETRO LORENZETTI
(ca. 1286–ca. 1348)
Virgin and Child (detail
of a polyptych)
Panel
Parochial Church, Arezzo

The slide reproduces only the central part of a large polyptch in several sections. To the sides of the Virgin and Child are Saints Donato, John the Evangelist, John the Baptist, and Matthew. In the upper register, there are small figures of eight saints and an Annunciation in the middle. In the cusps are depicted four saints and the Assumption Virgin. Pietro Lorenzetti was commissioned on April 17, 1320, to paint the polyptych by Bishop Guido Tarlati, who was also the lord (Ghibelline) of Arezzo. The picture bears the following signatures: PETRUS + LAURENTII + HANC + PINXIT + DEXTRA + SENENSIS (Pietro of Siena, son of Lorenzo, painted this panel with his right hand).

This is a work of the fully mature artist. Here all trace of the Byzantine manner and even of Duccio is gone, and the painter seems to have taken as a model a sculptural group by Giovanni Pisano (Figure 1). This is evident not only in the motif, but also in the manner in which the outline suggests the depth and motion of the forms.

A concern with form reminiscent of Florence is indicated by the manner in which the figures are set in their niche, and by the attempt to create a dynamic balance within the niche (e.g., the two hands of the Virgin, Her head and left arm, and the "S" curve of the mantle held on the right by Christ and on the left by Mary). But the painter was also acquainted with all the expressive subtleties of northern Gothic style, as can be seen in the sharp thin outline which marks the keen profile of Christ, His curls, and the long and angular fingers of Mary's hands.

· 16 ·

PIETRO LORENZETTI
(ca. 1286–ca. 1348)
*Scene from the Life
of Blessed Humilitas*
Panel, 12½″ x 17¾″
Uffizi Gallery, Florence

This scene is part of an altarpiece in which are depicted eleven scenes from the life of a little-known saint, Rosanese de' Negusanti dei Caccianemici from Faenza, who was known as Blessed Humilitas (d. 1310). In this scene Blessed Humilitas is carrying bricks gathered for the construction of the cloister of S. Giovanni Evangelista in Florence.

Today this painting is unanimously recognized as one of the masterpieces of Pietro Lorenzetti and was probably executed about 1335, when Pietro was in closest harmony with the work of his Florentine colleagues (Stefano, Maso di Banco, Taddeo Gaddi).

Pietro Lorenzetti shared the same stylistic concerns with these artists: the attempt to create a practicable setting, delimited by solidly constructed architecture, for the action depicted, and a range of color that was clear and bright but not strident—one that was very carefully harmonized and with a marked taste for geometric arrangements of large zones of solid and broadly applied color. Pietro adds to this his own talent for vivid and lively narration without falling into mere gossip.

These characteristics are even more evident in a scene such as ours, which represents an aspect of daily life in a fourteenth-century city—a mason carrying a basket of bricks on his shoulder; another one, with his trowel in his hand, looks out from a wall under construction; a third one, above, checks the perpendicular of the building with a plumb line.

But all the figures move with contained and gracious gestures, with a rhythm that is slow and sweet.

· 17 ·

Anonymous Master
(MASTER OF
CHIARAVALLE)
(circa 1350)
Annunciation
Fresco
Abbey of Chiaravalle, Milan

The frescoes of scenes from the Life of Mary that decorate the chancel of the Abbey of Chiaravalle, Milan, are, along with those of Viboldone, among the oldest documents of the grafting of Florentine artistic culture on that of the Po Valley. Until World War II, in fact, there was a frescoed "Assumption Virgin" by the same master in the Camposanto of Pisa.

The slide reproduces the Annunciation, which, like all the other frescoes in the cycle, is damaged in that the color has come away from the cloaks. What strikes one first is the poverty of decoration (the haloes are not even gilded). This is probably the fault of the commissioner, who either did not want to spend much money or was anxious that the work be finished in a hurry. However, the strictly figurative qualities of the painting are in no way diminished.

The Florentine training of the artist is indicated by the simple but grandiose placement of the figures and, even more, by the way he has created a spatial setting (even in this so simply arranged scene, which has no architectural elements at all). He has done this by bringing the angel closer to the observer and setting the Virgin farther toward the rear. Characteristically northern and "Gothic" on the other hand, is the pearly bluish tone of the flesh, which can also be seen in the work of Giovanni da Milano. This handling of flesh was probably inspired by the great admiration held for Gothic (particularly French) ivory statues.

· 18 ·

GIUSTO DE' MENABUOI

Marriage at Cana
Fresco
Baptistery, Padua

This fresco—which depicts the moment in which Christ miraculously transformed water into wine—is part of the decoration of the Baptistery of Padua, in which, about 1378, Giusto de' Menabuoi represented scenes from the Old and New Testaments. (The decorative cycle includes fifty-seven major frescoes and many subordinate ones.)

Substantially, the cycle is the fruit of the meeting of the Florentine sense of plasticity and space, represented by Maso di Banco, with the solemnity, solidity, and terrestrial concreteness of the Romanesque tradition of northern Italy. Giusto de' Menabuoi was an artist who systematically excluded from his paintings all trace of the Gothic. Notwithstanding, there is still evident the curious and attentive eye of an artist who can absorb every novelty in the line of visual examination of the "minimal" aspects of life—an examination that was being carried out everywhere in the Po Valley.

In this *Marriage at Cana* all the figures are depicted in action, but the total effect is, nevertheless, one of suspension, almost of immobility; but the painting comes alive through the warmth of its color, the truth of infinite details of the objects on the table, of fabrics, of wood, of marble, of the dogs and of the pages. And everything is bathed in light.

In comparison with the shadows that form under the small arches, with the linen table cloth fully lighted in the left foreground that extends to the half light of the back room, with the iridescent fabrics, and with the soft and lustrous flesh, the dramatic personages of Giotto all but seem to be painted marionettes, almost abstract figures.

· 19 ·

MASTER OF LENTATE

Crucifixion (detail)
Fresco
Oratorio di Santo Stefano,
Lentate

This is the detail of a Crucifixion that, with other frescoes, adorns the presbytery of an oratory that was built in 1369 by Stefano Porro as a family mausoleum.

The selection of the subjects of the other frescoes indicates a preference for decoration in a profane and chivalric key. The other frescoes are: Count Stefano Porro, with his family, presenting the model of the oratory to St. Stephen; St. George (the knightly saint) freeing the princess; St. Catherine of Alexandria (a saint from a royal family); and another (unidentified) knightly saint. But even the holy drama of the Crucifixion is used as a pretext for including large slices of contemporary life, for example, the squadron of red-bearded horsemen, and the figure of the young man in white on the left.

Nevertheless, the balance of the composition is not upset by this intrusion of everyday reality. The balance is solemn, modulated, and set in depth, after the example of Maso di Banco. There are broad surfaces so that color can be applied freely. Although the general tonality of color might at first seem rather drab, the warm and dark background is skillfully modulated (note the "acute" note struck in the golden yellow waistband of the first rider in the second row) and gives greater relief to the few brilliant notes (red, green), which are also perfectly harmonized.

43

· 20 ·

GIOVANNI DA MILANO
(ca. 1320–ca. 1370)
*Joachim Expelled from
the Temple*
Fresco
Santa Croce, Florence

This fresco is part of a cycle of scenes from the Life of Mary that Giovanni da Milano left incomplete in 1366. The fresco cycle was completed by 1371 by a modest Florentine artist who is usually called the "Master of the Rinuccini Chapel," after the chapel in which the frescoes are painted. This fresco, according to the inscription, depicts "how St. Joachim, father of the Blessed Mary, was, with his offering, expelled from the temple . . ."

From the point of view of composition, the fresco has a simplicity and symmetry that are designed to create an effect of great hieratic solemnity. The architecture, in perfect central perspective, helps everything converge on the central scene under the highest arch.

This, as we have already noted, is a fundamental principle of the art of Giotto. But when we turn to examine details, we see how far the artist has moved away from Giotto, creating profound innovations. His naturalism is exceedingly advanced. The picture is cut out in such a way that a painted arch appears as if it were a real arch, part of the masonry of the chapel. Even more important is the determining value of light. It marks off the shaded depths of the architecture, it clearly outlines the figures of the offering-bearers, and brings out the qualities of the materials. Note, too, that in spite of the "choral" effect of the masses, the individuals are studied to the last detail with an acuity that anticipates that of the fifteenth-century Flemish painters.

· 21 ·

VITALE DA BOLOGNA
(ca. 1300–ca. 1360)
Saint George and the Dragon
Panel, 27½″ x 33½″
Pinacoteca, Bologna

This is one of the fundamental works of the leading painter of the school of Bologna, Vitale Cavalli (or Vitale degli Equi). The work is in the purest and most impetuous Bolognese Gothic style and shows no trace of Tuscan influence. Consequently, it should be dated to his earlier years, between 1330 and 1340 at the latest.

From the point of view of style, it is useful to compare this painting with the Saint Michael of Ambrogio Lorenzetti (*Slide 13*). This brings out clearly the difference between the rhythmic Gothic of the Sienese and the passionate and violent Gothic style of the Bolognese painters. Everything in the painting works together to express the burst of motion of the rider who drives his lance into the dragon's jaw; everything emphasizes the tremendous force of the mortal blow. The dynamic contrasts are vigorously marked so as to accentuate the sense of tension and instability. The two arms of the saint form a kind of powerful shaft that, on one end, drives the lance, and, on the other, pulls the bridle of the neighing horse, mad with terror. A similar effect of contrasting effort is achieved by the foot pressed hard in the stirrup to gain greater forward impetus. A piece of the red tunic is rigid, revealing its green reverse, while the hair in the wind once again indicates the direction of the lethal blow.

From the point of view of pictorial quality, there is an attention to the material aspect of things that is altogether characteristic of Po Valley painting—in the sweaty hair of the horse's muzzle, and the tightly woven chain mail of iron and gold worn by Saint George.

44

"L'ILLUSTRATORE"
*Stories from the Life
of St. Catherine*
Miniature on parchment
Cathedral Archives, Padua

This is one of the most typical and beautiful pages of Bolognese miniature work. The anonymous artist, whose style has strong and easily recognizable characteristics, is conventionally called "Pseudo-Niccolò," or, more simply, "L'Illustratore," for his talent as a narrator and illustrator.

In this page from a codex of juridical provisions, we see, in addition to the main scene, some minor illustrations: above left is a portrait, with strongly marked features, of the gloss writer; above center is St. Peter (between two angels) holding the keys of the kingdom of heaven in his right hand and the Aristotelian world in his left; below left a bishop is portrayed seated on a bench as he sharpens the point of his pen with the greatest air of unconcern.

The four scenes in the center recapitulate the principal episodes of the legend of St. Catherine of Alexandria. In the first scene the saint (whose crown and ermine-lined red cloak indicate that she is the daughter of a king, but whose features are barely distinguishable from those of the chubby damsel in green and pink) receives an icon of the Virgin and Child from a hermit. In the second scene, the mystic marriage of St. Catherine and Christ is depicted with a very original iconography. The scene takes place in the bedroom of the saintly princess (the hermit's icon sits on the small chest). St. Catherine has either fallen asleep reading (the book is still open on the bench to the left) or gone into delirium at the appearance of the Madonna, who holds her by one arm as Christ puts on the ring. In the third scene an angel appears to save her from martyrdom on the wheel. He spins the wheel so fast that the blades break off and fall like murderous rain on the jailers. In the fourth and last scene are depicted the martyrdom of St. Catherine and the bearing of her body by angels to Mt. Sinai.

The bright and brilliant color, the taste for lively and almost irreverent narration, the almost caricaturized psychological characterization, and the attention to the material quality of things are marks of an artist who has strongly and consciously moved away from the harmonious and intellectualistic culture of Tuscany in order to express, with vigorous originality, his own more sanguine and sensuous conception of the world.

MASTER OF THE
TRIUMPH OF DEATH
The Triumph of Death (detail)
Fresco
Camposanto, Pisa

This slide is a detail of a large fresco in which the anonymous artist has brought together two late-medieval themes—that of the "triumph of death" and that of the "legend of the three living and three dead." Our detail depicts the moment in which a group of noble hunters, richly and bizarrely dressed, stop horrified before three open coffins in which are three corpses in different stages of putrefaction. Even in this detail (which is cut in such a way as to exclude the corpses to the left and the beggars invoking death to the right), we can see clearly the painter's gifts for effective narration using a strong and incisive style of drawing that pitilessly outlines every detail. The reactions of the horsemen are skillfully distinguished and graduated. One turns to point out the coffins to the others. The lady reacts by assuming a meditative and sorrowful attitude. At the same time another horseman covers his nose so as not to smell the foul odor, while the rider behind him leans forward for a better look. The others have as yet noticed nothing.

This skill in vivid narration, along with the fact that the frescoes were painted in Pisa, has led some critics to attribute the work to the outstanding Pisan artist of the time, Francesco Traini (*Slide 12*). But that artist, who was influenced by Simone Martini, always maintains a more refined and aristicratic tone. Here, instead, there is an expressive force that is not afraid to risk a loss in elegance of compositional balance. And there is a mixture of the horrible with the refined that would be more easily explained if the artist's background had been northern Italian, in particular Bolognese.

On the other hand, the remains of frescoes by Florentine artists in Santa Croce, Florence, demonstrate that as far as the iconography is concerned, our artist must, at least in part, have followed a Tuscan model. This may have partially subdued his expressive force. In fact, when the frescoes in the Camposanto were taken from the walls after bombardment in World War II, the underlying preparatory drawing *(sinopia)* was absolutely free, almost impressionistic, and not schematic and structural like Tuscan work.

The fresco represents a highly interesting case of a meeting between Tuscan and Bolognese artistic cultures just after the middle of the fourteenth century.

· 24 ·

LORENZO VENEZIANO
(ca. 1325–ca. 1385)
*The Marriage
of St. Catherine*
Panel, 23″ x 37⅞″
Academy, Venice

This panel, according to the inscription in Venetian dialect, was painted in Venice by "Lorenzo the painter" on February 20, 1359. We have selected it to show the origins, in the middle of the fourteenth century, of a school of painting that was to become famous, particularly in successive centuries, thanks to Bellini, Carpaccio, Giorgione, Titian, and Paolo Veronese.

As early as the fourteenth century, this school acquired a character of its own for the particular way in which new artistic developments, from Giotto to the Gothic Po Valley artists, reacted on the Byzantine background of Venetian art. The Byzantine element was particularly strong in Venice because of the close commercial bonds between the Adriatic port and Constantinople.

Lorenzo Veneziano marks the conclusion of this evolution, which had begun with Master Paolo. In Lorenzo's work the contributions of Bolognese art overwhelm elements of eastern tradition.

This panel represents the mystic marriage of St. Catherine with the Christ Child. St. Catherine is depicted on the left as a very beautiful young woman accompanied by an angel dressed as a deacon. She extends her hand for the wedding ring. The Virgin and Child are depicted in the Glory of Heaven, surrounded by angel musicians. The depictions of the bright red sun and the sad green moon, below, also indicate that the group is high in the sky.

The rich brocades worn by the Madonna and St. Catherine (her dress is even trimmed with fur) give the scene a sumptuousness in harmony with the courtly Byzantine traditions of Venice. But the representational vitality revealed in the details indicates the personality of a strong artist who had learned much from the painters of the Bolognese school (*Slides 22 and 23*) about studying the episodic aspects of real life. One should also note how the artist has given Christ a turning motion so that, while He is putting the ring on St. Catherine's finger, He turns smiling to look for approval in His mother's eyes. She holds Him so that in His impetuous movement He will not fall. Thus in this sacred scene, an episode of everyday life is artistically inserted.

THE COLOR SLIDE BOOK OF THE WORLD'S ART